Victoria and Albert Museum

Sketches by
JOHN CONSTABLE
in the Victoria and Albert Museum

C. M. KAUFFMANN

London Her Majesty's Stationery Office

ISBN 0 11 290343 6

List of illustrations

The illustrations are listed in chronological order, following Constable's artistic development. 1–53 are black and white illustrations; I–XII are colour plates. Sizes are given in inches followed by centimetres, height before width. 'R' numbers refer to G. Reynolds, *Catalogue of the Constable Collection*. All works were given to the Museum by Isabel Constable, unless otherwise indicated.

II. FLATFORD MILL FROM A LOCK ON THE STOUR, c. 1810–11
Oil on canvas;
9¾ × 11¾ (24·8 × 29·8) No. 135–1888 (R.103)

14. BARGES ON THE STOUR, WITH DEDHAM CHURCH IN THE DISTANCE, c. 1811
Oil on paper laid on canvas;
10¼ × 12¼ (26 × 31·1) No. 325–1888 (R.104)

15. SALISBURY CATHEDRAL: EXTERIOR FROM THE SOUTH-WEST, September 1811
Black and white chalk on grey paper;
7⅝ × 11¾ (19·5 × 29·9) No. 292–1888 (R.105)
Inscribed on the back by the artist *Salisbury Cathedral Sepr. 11 & 12—1811—S.W. view*

16. EAST BERGHOLT CHURCH: THE RUINED TOWER AT THE WEST END, c. 1810–15
Oil on canvas;
9¾ × 13⅜ (14·8 × 34) No. 130–1888 (R.112)

17. A HAYFIELD NEAR EAST BERGHOLT AT SUNSET, 4 July 1812
Oil on paper;
6¼ × 12½ (16 × 31·8) No. 121–1888 (R.115)

18. LANDSCAPE AND DOUBLE RAINBOW, 28 July 1812
Oil on paper laid on canvas;
13¼ × 15⅛ (33·7 × 38·4) No. 328–1888 (R.117)

III. WILLY LOTT'S HOUSE NEAR FLATFORD MILL, c. 1810–15
Oil on paper;
9½ × 7⅛ (24·1 × 18·1) No. 166–1888 (R.110)

IV. DEDHAM MILL, c. 1810–15
Oil on paper;
7⅛ × 9¾ (18·1 × 24·8) No. 145–1888 (R.113)
A sketch for R.184 of 1820.

V. DEDHAM LOCK AND MILL, 1820.
The exhibited picture.
Oil on canvas;
21⅛ × 30 (53·7 × 76·2) No. FA 34 (R.184)
Sheepshanks Gift
Signed and dated *John Constable, ARA. pinxt. 1820*

19. STUDY OF FLOWERS IN A GLASS VASE, c. 1814
Oil on millboard, laid on panel;
19⅞ × 13 (50·5 × 33) No. 581–1888 (R.130)

20. STUDY OF A CART AND HORSES, WITH A CARTER AND DOG, 1814
Oil on paper with a brown ground;
6½ × 9¾ (16·5 × 23·8) No. 332–1888 (R.135)

21. STUDY FOR THE PAINTING BOAT-BUILDING NEAR FLATFORD MILL, September 1814
Page in a sketch book, pencil;
3¼ × 4¼ (8 × 10·8) No. 1259–1888 (R.132, p.57)
Inscribed top left *Sepr. 7. 1814. Wednesday*

22. BOAT-BUILDING NEAR FLATFORD MILL, 1815. The exhibited picture.
Oil on canvas;
20 × 24¼ (50·8 × 61·6) No. FA 37 (R.137)
Sheepshanks Gift
This is unusual among Constable's exhibition pictures in that it was painted entirely out of doors.

23. VIEW AT EAST BERGHOLT OVER THE KITCHEN GARDEN OF GOLDING CONSTABLE'S HOUSE, c. 1812–16
Pencil;
11⅞ × 17¾ (30·2 × 44·9) No. 623–1888 (R.176)

24. ELM TREES IN OLD HALL PARK, EAST BERGHOLT, 22 October 1817
Pencil with slight grey and white washes;
23¼ × 19½ (59·2 × 49·4) No. 320–1891 (R.162)
Inscribed by the artist *Octr. 22d 1817 East Bergholt* and *John Constable 1817*

25. HOUSES AT PUTNEY HEATH, 13 August 1818
Pen and water-colour;
4¾ × 10⅝ (12·1 × 27) No. 172–1888 (R.165)
Inscribed by the artist *Putney Heath Augst. 13th. 1818*

1819–24 The Six-Foot Canvases; Hampstead and Cloud Studies; Salisbury and Brighton

VI. BRANCH HILL POND, HAMPSTEAD,
October 1819
Oil on canvas;
10 × 11⅞ (25·4 × 30) No. 122–1888 (R.171)
Used by Constable as a sketch for many paintings of
Hampstead Heath, including No. R.171 (see Fig. 41).

26. WATERLOO BRIDGE FROM WHITEHALL
STAIRS, c. 1819
Study for the painting *Waterloo Bridge from Whitehall
Stairs June 18th, 1817* (private collection).
Oil on Millboard;
11½ × 19 (29·2 × 48·3) No. 322–1888 (R.174)
G. R. Rennie's Waterloo Bridge was opened by the Prince
Regent on 18 June 1817. Constable began his series of
sketches in 1819, but the final painting was only exhibited
at the Royal Academy in 1832.

27. SALISBURY CATHEDRAL AND CLOSE,
August 1820
Oil on canvas;
9⅞ × 11⅞ (25·1 × 30·2) No. 318–1888 (R.196)

28. FULL-SCALE STUDY FOR 'THE HAY
WAIN', c. 1821
Oil on canvas;
54 × 74 (137 × 188) No. 987–1900 (R.209)
Bequeathed by Henry Vaughan
This is the full-scale study for the painting exhibited by
Constable at the Royal Academy in 1821 and now in the
National Gallery.

29. A WATER-MILL AT NEWBURY, BERKS,
4 June 1821
Pencil and grey wash;
6¾ × 10¼ (17·3 × 26) No. 285–1888 (R.211)
Inscribed by the artist *Newbury Berks June 4, 1821*

30. THE OLD BRIDGE AT ABINGDON, BERKS,
7 June 1821
Pencil;
6¾ × 10¼ (17·3 × 26·1) No. 282–1888 (R.217)
Inscribed by the artist *Old Bridge, Abingdon June 7. 1821*

VII. STUDY OF SKY AND TREES, WITH A
RED HOUSE AT HAMPSTEAD, 12 September 1821
Oil on paper;
9½ × 11¼ (24·1 × 29·8) No. 156–1888 (R.222)
Inscribed on the back by the artist *Sepr. 12. 1821. Wind
fresh at West . . . Sun very Hot. looking Southward
exceedingly bright vivid & Glowing*

VIII. STUDY OF SKY AND TREES, c. 1821
Oil on paper;
9¾ × 11¾ (24·8 × 29·8) No. 162–1888 (R.230)

31. A SANDBANK AT HAMPSTEAD HEATH,
2 November 1821
Oil on paper;
9¾ × 11¾ (24·8 × 29·8) No. 164–1888 (R.228)
Inscribed on the back by the artist *Novr. 2d 1821.
Hampstead Heath windy afternoon.*

32. BRANCH HILL POND, HAMPSTEAD (?)
Oil on canvas;
9⅝ × 15½ (24·5 × 39·4) No. 125–1888 (R.233)

IX. STUDY OF TREE TRUNKS, c. 1821
Oil on paper;
9¾ × 11½ (24·8 × 29·2) No. 323–1888 (R.234)

X. THE GROVE, OR ADMIRAL'S HOUSE,
HAMPSTEAD, c. 1821–2
Oil on paper, laid on canvas;
9⅝ × 11½ (24·5 × 29·2) No. 137–1888 (R.402)

33. OLD HOUSES ON HARNHAM BRIDGE,
SALISBURY, 14 November 1821 (retouched 9 September
1831)
Pencil and water-colour;
6¾ × 10¼ (17·3 × 26·2) No. 218–1888 (R.240)
Page from a sketch-book
Inscribed lower left by the artist *14 Nov. 182(1)*. This date
and the date of the retouching is inscribed on the back.

34. TREES, SKY AND A RED HOUSE, c. 1821–3
Pencil and water-colour;
6¾ × 10 (17·3 × 25·5) No. 594–1888 (R.242)
Page from a sketch-book

35. STUDY OF CIRRUS CLOUDS, c. 1822
Oil on paper;
4½ × 7 (11·4 × 17·8) No. 784–1888 (R.250)
Inscribed on the back by the artist, underneath a later
inscription *cirrus* (?)

36. CENOTAPH TO SIR JOSHUA REYNOLDS AMONGST LIME TREES IN THE GROUNDS OF COLEORTON HALL, LEICESTERSHIRE, 28 November 1823
Pencil and grey wash;
10¼ × 7⅜ (26 × 18·1) No. 835–1888 (R.259)
Page from a sketch-book
Inscribed on the back by the artist *Coleorton Hall, Novr. 28. 1823* and with Wordsworth's verse written for the monument.
The monument to Reynolds was erected by Sir George Beaumont, Constable's friend and patron, in 1812. Constable used this drawing as the basis of a large painting exhibited at the R. A. in 1836, now in the National Gallery.

XI. BRIGHTON BEACH, WITH COLLIERS, 19 July 1824
Oil on paper;
5⅞ × 9¾ (14·9 × 24·8) No. 591–1888 (R.266)
Inscribed on the back with date.

37. HOVE BEACH, WITH FISHING BOATS, c. 1824
Oil on paper, laid on canvas;
11¾ × 19⅜ (29·8 × 49·2) No. 129–1888 (R.270)

38. FULL SCALE STUDY FOR 'THE LEAPING HORSE', c. 1825
Oil on canvas;
51 × 74 (129·4 × 188) No. 986–1900 (R.286)
Bequeathed by Henry Vaughan.
This is the full-scale study for the painting exhibited by Constable at the Royal Academy in 1825 and now in the Royal Academy.

1827–37: The Last Decade

39. WATER LANE, STRATFORD ST. MARY, SUFFOLK, 4 October 1827
Pencil and grey wash;
13 × 8⅞ (33 × 22·4) No. 624–1888 (R.291)
Page from a sketch-book
Inscribed lower left by the artist *Stratford Water Lane. Oct. 4 1827*

40. MAN LOADING BARGES ON THE STOUR, October 1827
Pencil, pen and grey wash;
8⅞ × 13 (22·5 × 33·1) No. 242–1888 (R.300)
Inscribed upper left by the artist *Silvery Clouds Bright and Blue*

41. HAMPSTEAD HEATH: BRANCH HILL POND, 1828: the exhibited picture
Oil on canvas;
23½ × 30½ (59·6 × 77·6) No. FA 35 (R.301)
Sheepshanks Gift
No. R.171 (pl. VII) is the sketch for this work which was exhibited at the Royal Academy in 1828. It is much more sketchy than Constable's "finished" pictures of earlier years; a comparison with pl. VII demonstrates the diminishing difference between the sketch and the exhibited picture at this period.

42. A COTTAGE AND TREES NEAR SALISBURY, 28 July 1829
Black chalk and water-colour;
9¼ × 13¼ (23·4 × 33·6) No. 210–1888 (R.315)
Page from a sketch-book
Inscribed lower left by the artist *July 28. 1829 near Salisbury*

43. A VIEW AT SALISBURY FROM ARCHDEACON FISHER'S HOUSE, 1829 (?)
Oil on canvas;
7⅞ × 9⅞ (20 × 25·1) No. 320–1888 (R.320)

44. STUDY OF CLOUDS ABOVE A WIDE LANDSCAPE, 15 September 1830
Pencil and water-colour;
7½ × 9 (19 × 22·8) No. 240–1888 (R.328)
Inscribed on the back by the artist *about 11—Noon—Sepr. 15 1830. Wind—W.*

45. A COUNTRY ROAD WITH TREES AND FIGURES, c. 1830
Oil on canvas;
9½ × 13 (24·2 × 33) No. 787–1880 (R.329)
This is a version of *A cart on a lane at Flatford* of 1811 (R.100) and was probably worked up by Constable in his studio from the earlier sketch.

46. A DOG WATCHING A RAT IN THE WATER AT DEDHAM, 1 August 1831
Pencil and water-colour;
7¼ × 8⅝ (18·5 × 22·6) No. 235–1888 (R.334)
Inscribed on the back by the artist *Dedham August 1st 1831*.

47. STOKE POGES CHURCH, BUCKINGHAM-SHIRE. Illustration to Gray's *Elegy*, July 1833
Water-colour;
5¼ × 7¾ (13·3 × 19·8) No. 174–1888 (R.354)
Inscribed on the back by the artist:
Stanza 5th— "The breezy call of incense breathing morn,

.

.

No more shall rouse them from their lowly bed."
John Constable R.A. July 1833
Constable made a number of designs to illustrate Gray's *Elegy*, but this drawing was not engraved in the published edition.

48. HAMPSTEAD HEATH FROM NEAR WELL WALK, 12 April 1834
Water-colour;
4⅜ × 7⅛ (11·1 × 18) No. 175–1888 (R.360)
Inscribed on the back by the artist *Spring Clouds—Hail Squalls—April 12 1834—Noon Well Walk—*

49. PETWORTH HOUSE FROM THE PARK, September 1834
Pencil and water-colour;
8⅛ × 10¾ (20·7 × 27·2) No. 801–1888 (R.372)
Page from a sketch-book
Constable stayed with Lord Egremont at Petworth in September 1834.

50. AN ASH TREE, c. 1835
Pencil and water-colour, squared for enlargement;
39 × 26¾ (99 × 68) No. 1249–1888 (R.375)
On paper watermarked: J. WHATMAN 1833
Probably an enlargement of a tree in an earlier sketch (R.163), the drawing was made as a preparatory study for the ash tree in the right foreground of *The Valley Farm* (Tate Gallery).

51. A SUFFOLK CHILD: sketch for *The Valley Farm*
Pencil and water-colour;
7¼ × 5⅜ (18·5 × 13·7) No. 600–1888 (R.377)
In the exhibited picture the countrywoman in the boat has been given older features.

XII. RIVER SCENE, WITH A FARMHOUSE NEAR THE WATER'S EDGE, c. 1830–6
Oil on canvas;
10 × 13¾ (25·4 × 34·9) No. 141–1888 (R.403)

52. A SLUICE, PERHAPS ON THE STOUR: TREES IN THE BACKGROUND, c. 1830–6
Oil on paper laid on canvas;
8⅝ × 7¾ (21·9 × 18·7) No. 131–1888 (R.404)

53. VIEW ON THE STOUR, DEDHAM CHURCH IN THE DISTANCE, c. 1832–6
Pencil and sepia wash;
8 × 6⅝ (20·3 × 16·9) No. 249–1888 (R.410)

I. DEDHAM VALE: EVENING, 1802

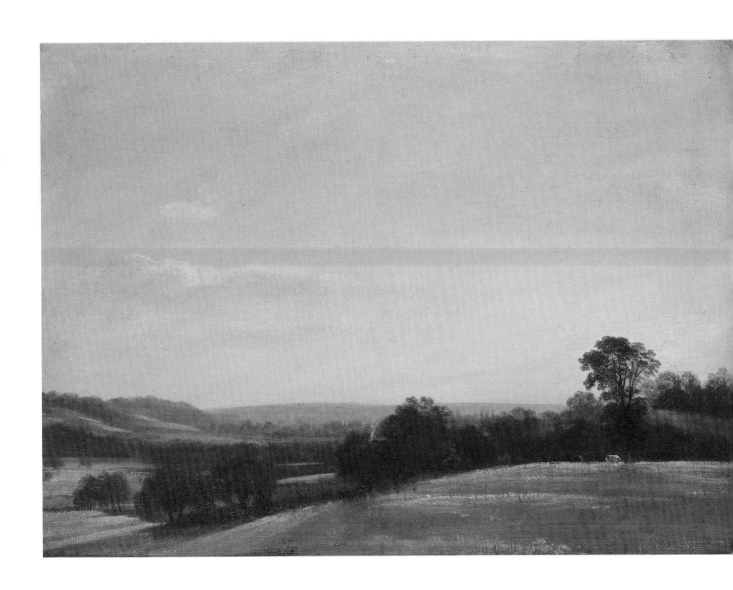

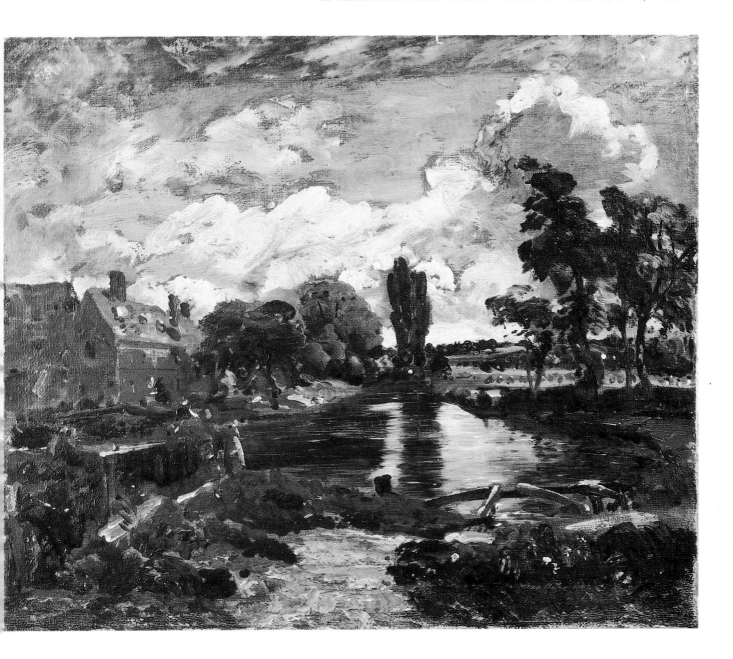

Sketches by John Constable (1776-1837) in the Victoria and Albert Museum

Why sketches? And why the Victoria and Albert Museum? These questions are soon answered. For the sketch is central to Constable's art, and the essence of this art—the depiction of his native landscape in a naturalistic manner—can be grasped much more readily in his sketches than in his finished paintings. Indeed, during the first half of his career, he painted hardly any finished exhibition pictures,

and even after he concentrated more on these, from about 1819, he continued to be most inventive in his sketches. In particular, he used the *plein air* oil sketch as the main vehicle for translating landscape into art in the most direct way possible. He was not the first to do so—there are, for example, the splendid oil sketches of Pierre-Henri de Valenciennes (1750–1819)—but Constable was the most consistent exponent of the oil sketch since Rubens.

1. COTTAGE AT EAST BERGHOLT, 1796

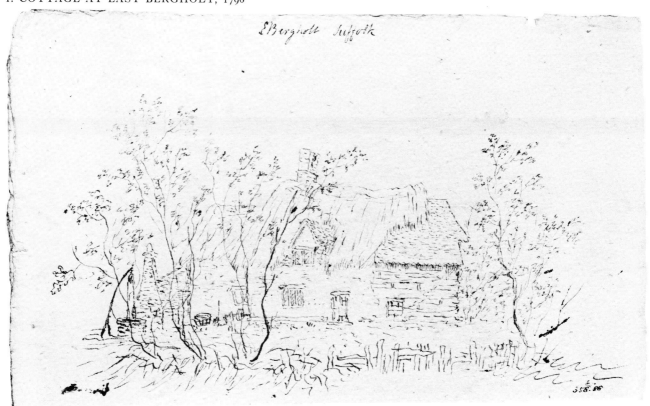

Several paintings by Constable reached the Victoria and Albert Museum in 1857 in the gift of John Sheepshanks, who had known the artist, but the great bulk of the collection was received from Isabel Constable in 1888. She was the artist's last surviving daughter and had inherited the remains of his studio. Her magnificent gift of some 400 sketches at once made the Victoria and Albert Museum the principal single repository of Constable's work. The collection also includes several outstanding finished paintings that were exhibited at the Royal Academy, of which *Boat building near Flatford Mill* (1815) and *Salisbury Cathedral* (1823) are perhaps the best known, but it is on the sketches that its unique position rests. The exhaustive catalogue of the collection by Graham Reynolds is a standard book of reference for the painter's *oeuvre*.

2. EAST BERGHOLT CHURCH, c. 1796–9

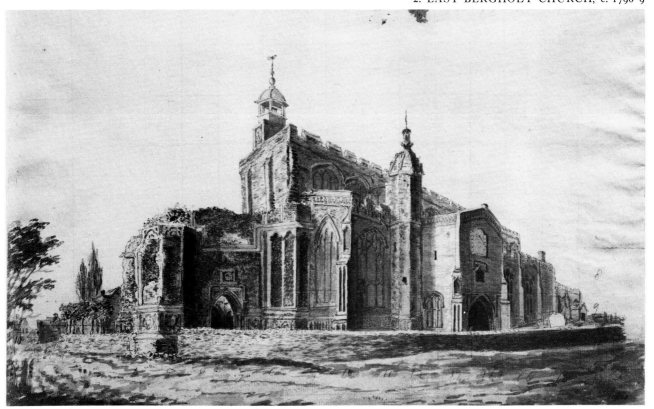

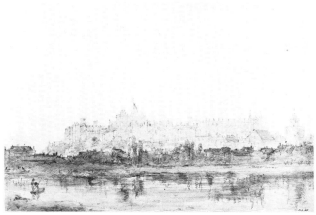

3. THE ENTRANCE TO THE VILLAGE OF
EDENSOR, DERBYSHIRE, 1801

4. WINDSOR CASTLE FROM THE RIVER, 1802

5. DEDHAM VALE, 1802

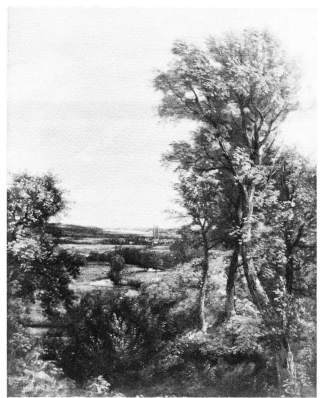

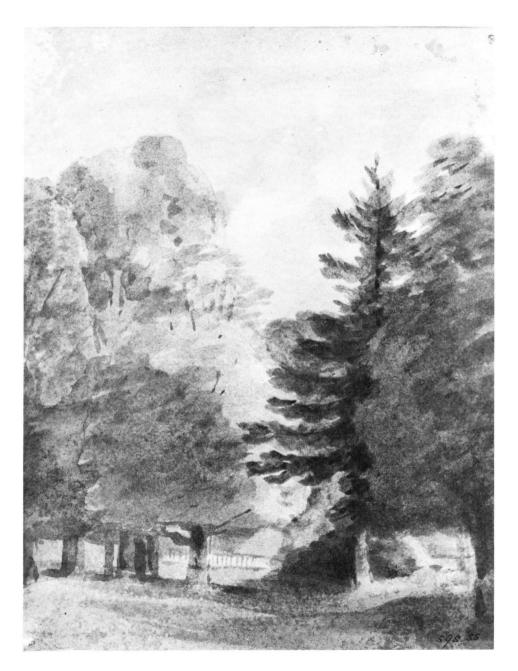

6. STUDY OF TREES IN
A PARK, PERHAPS
HELMINGHAM PARK,
SUFFOLK, 1805

Early years

John Constable was born at East Bergholt, on the Suffolk-Essex border, the son of Golding Constable, a prosperous miller, the owner of the mills at nearby Flatford and Dedham on the River Stour. For most artists such a statement, once made, could be rapidly passed over, but for Constable it contains the key to his art. A large number of the subjects he painted were taken from the area of East Bergholt—Dedham—Flatford, from the River Stour with its horse-drawn barges and changing vistas; and, in a deeper sense,

he drew his inspiration from this flat, unemphatic, agricultural landscape. "I associate 'my careless boyhood' with all that lies on the banks of the Stour; these scenes made me a painter, and I am grateful."

But his development as a painter was slow. He began painting at the age of about 16 or 17 under the guidance of John Dunthorne, the village plumber and glazier and a keen amateur artist, and a little later received the encouragement of Sir George Beaumont, a collector, patron and artist of considerable renown. Among Constable's earliest works are the cottages [1], which he drew for the antiquarian

7. DEDHAM VALE, c. 1805

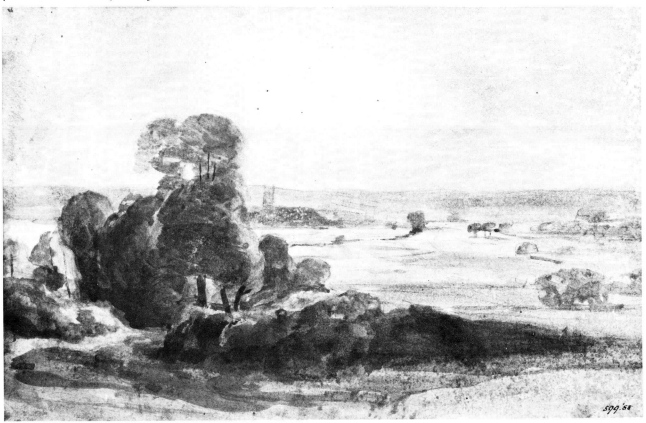

and engraver J. T. Smith (his first acquaintance among professional artists), and which serve to demonstrate his slow beginnings. For when Constable produced these amateurish drawings in 1796, Turner, who was but one year his senior, was already widely known as one of the leading water-colourists of his generation. The first fruits of Constable's efforts at self education appear in the earliest

8. CATTLE NEAR THE EDGE OF A WOOD, c. 1800–5

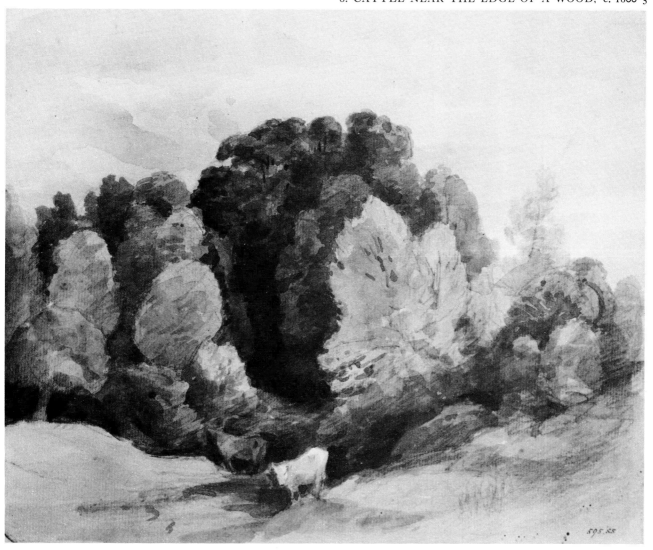

depiction of East Bergholt church in about 1797, which may be seen as an exercise in perspective [2].

A turning point came in 1799 when he at last obtained his father's permission to leave the family business. He moved to London and was admitted to the Royal Academy Schools, where he learnt to draw from the nude and from plaster casts of antiquities. An early attempt to follow the current fashion for painting romantic scenery led

9. THE VALLEY OF THE STOUR WITH DEDHAM IN THE DISTANCE, c. 1800-5

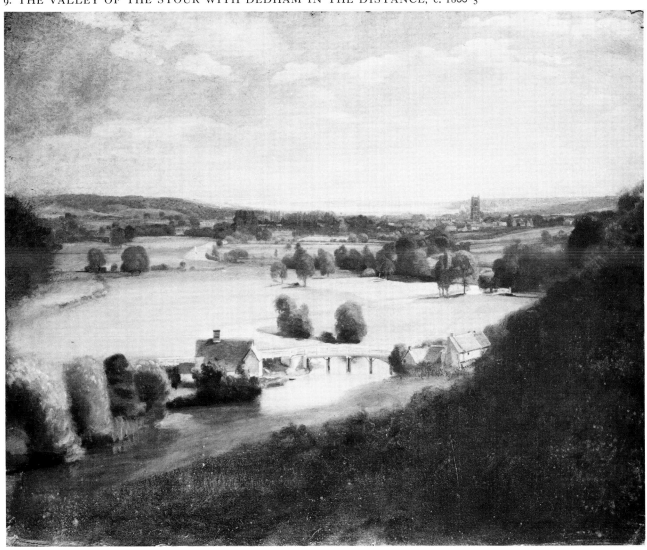

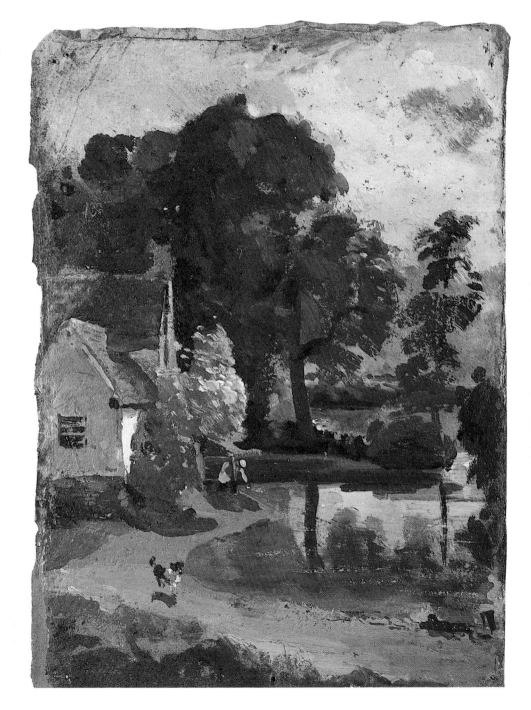

IV. DEDHAM MILL, c. 1810–15

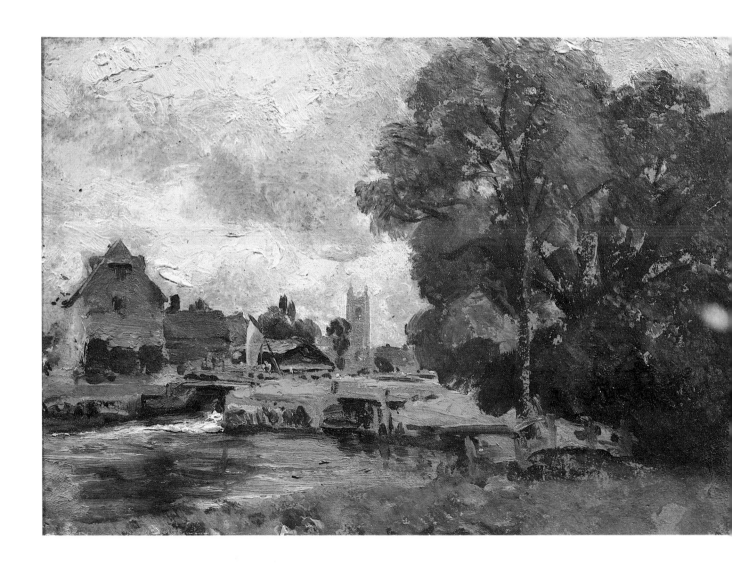

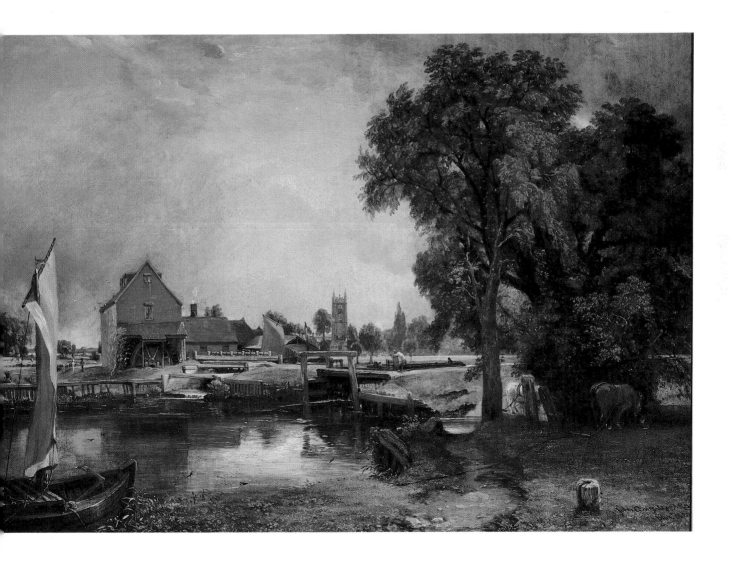

to his tour of the Derbyshire Peak district in 1801. His drawings of that time [3], while not perhaps of outstanding interest, show, particularly in the accomplished use of wash shading, how far Constable had advanced from the cottages of 1796.

The year 1802 was another landmark, for it was then that Constable decided to return to East Bergholt and to concentrate on "laborious studies from nature" in his native countryside: "there is room enough for a natural painter", as he wrote to his old friend John Dunthorne. An early result of this determination was the oil sketch of *Dedham Vale* showing the winding course of the River Stour down to the estuary at Harwich [5]. The composition is based on Claude's *Landscape with Hagar and the Angel* (now in the National Gallery, London), one of the many old master paintings which Constable had seen and studied at the house of Sir George Beaumont, and the brownish tonality is redolent of 18th century English landscape. Yet, even though the influence of Claude and Richard Wilson upon this painting is unmistakeable, it nevertheless represents an early stage of Constable's determination to portray his homeland in a direct manner. Indeed, the early development of Constable provides a text book example of the dictum, fully explored in E. H. Gombrich's *Art and Illusion*, that the artist learns more from other artists than from nature. For in his formative years, Constable adapted his landscapes to the conventions of older masters. The drawing of *Cattle at the edge of a wood* [8] mirrors the art of Gainsborough both in composition and technique, an influence probably transmitted by George Frost, Gainsborough's follower and Constable's friend. On the other hand, the water-colours he painted in the Lake District in 1806 [11, 12] are indebted to the Romantic vision of J. R. Cozens and to the colouring of Thomas Girtin. Constable's

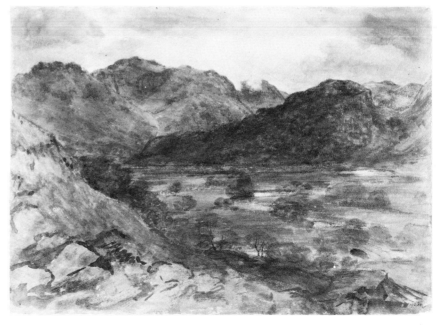

10. A LADY SEATED, c. 1805

11. VIEW IN BORROWDALE, 1806

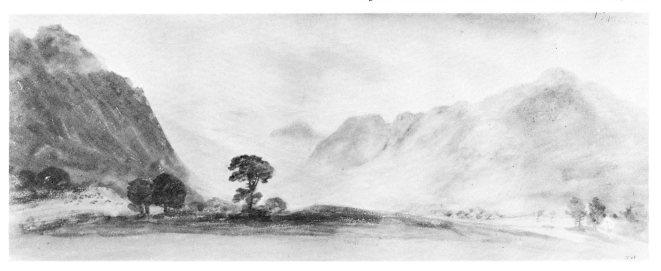

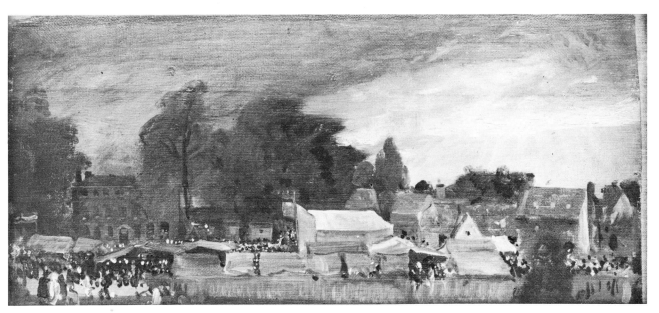

tour of the Lake District represents his last effort to follow the fashion for painting the sublime landscape of craggy mountains and mysterious lakes. He found the mountains oppressive and never became attuned to this kind of scenery, but these water-colours are the earliest on which he recorded his interest in transient weather conditions. The *View in Borrowdale*, [11] for example, is inscribed on the back: *25 Sep. 1806—Borrowdale—fine clouday day tone very mellow like—the mildest of Gaspar Poussin and Sir G(eorge) B(eaumont) and on the whole deeper toned than this drawing.* Even while he was so concerned with natural phenomena, this reference to other artists is a clear indication of Constable's struggle to develop his approach to nature through the mediation of earlier painters.

The influence of Claude and Gaspar Poussin, of Richard Wilson and Gainsborough, and of the English water-colour painters was assimilated by Constable at this period; his debt to the Dutch masters of the 17th century and, of the Flemings, to Rubens was perhaps even more profound. His early Academy pictures are very reminiscent of the Dutch school and in particular he recognised a kindred spirit in Jacob van Ruisdael, whose rain-filled clouds and mellow tones provide a close parallel to Constable's work. As to Rubens, we know that Constable's encounter in 1804 with the *Château de Steen* at Sir George Beaumont's made a lasting impression. Constable shared the preoccupation with rainbows [18] and, in more general terms, was attracted by what he termed Rubens's masterly treatment of "dewy light and freshness, the departing shower, with the exhilaration of the returning sun . . .".

Several of the directions taken by Constable in the first decade of the century have been described as false starts. He painted altarpieces and drew ships, attempted picturesque mountain landscapes and struggled to earn a living as a portrait painter. False starts they certainly were in the light of Constable's subsequent development, but we should be poorer without his rugged Lakeland views [11, 12] and his delightful portrait sketches [10]. Yet it remains true that Constable was slow to develop his full powers and there are indications in his correspondence that this was connected with his proneness to self-doubt, to anxiety and to moods of depression which affected his ability to work.

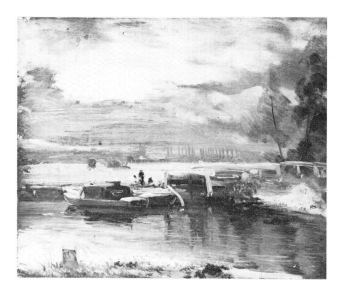

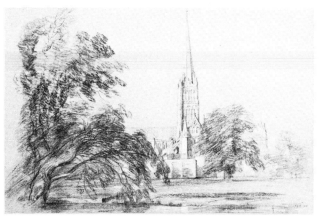

14. BARGES ON THE STOUR, WITH DEDHAM CHURCH IN THE DISTANCE, c. 1811

15. SALISBURY CATHEDRAL: EXTERIOR FROM THE SOUTH-WEST, 1811

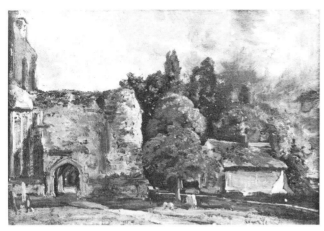

16. EAST BERGHOLT CHURCH: THE RUINED
TOWER AT THE WEST END, c. 1810-15

17. A HAYFIELD NEAR EAST BERGHOLT AT
SUNSET, 1812

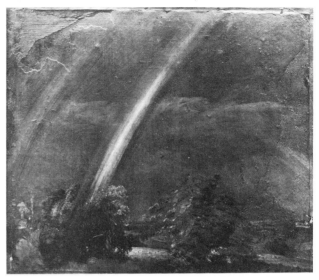

18. LANDSCAPE AND DOUBLE RAINBOW, 1812

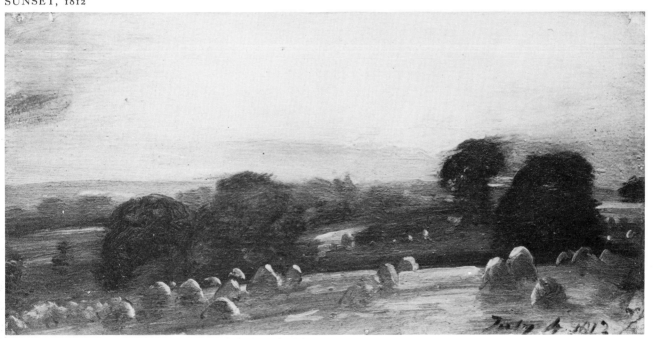

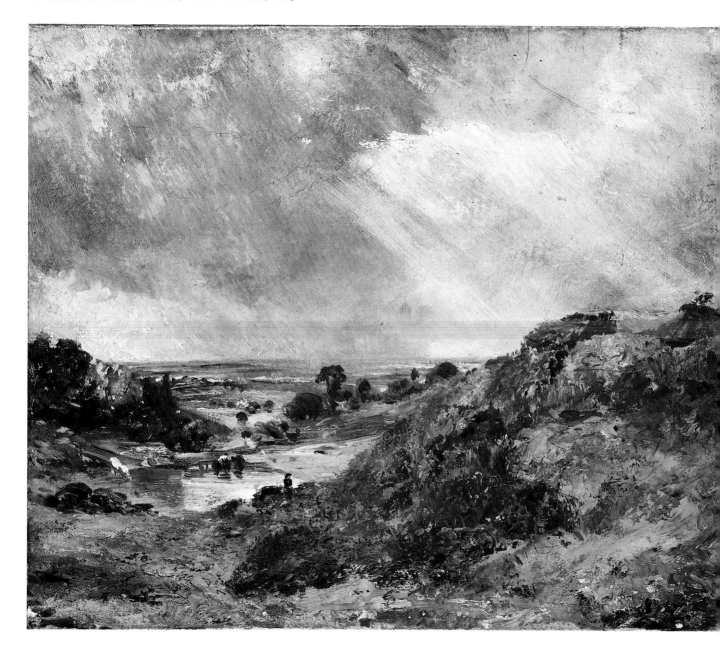

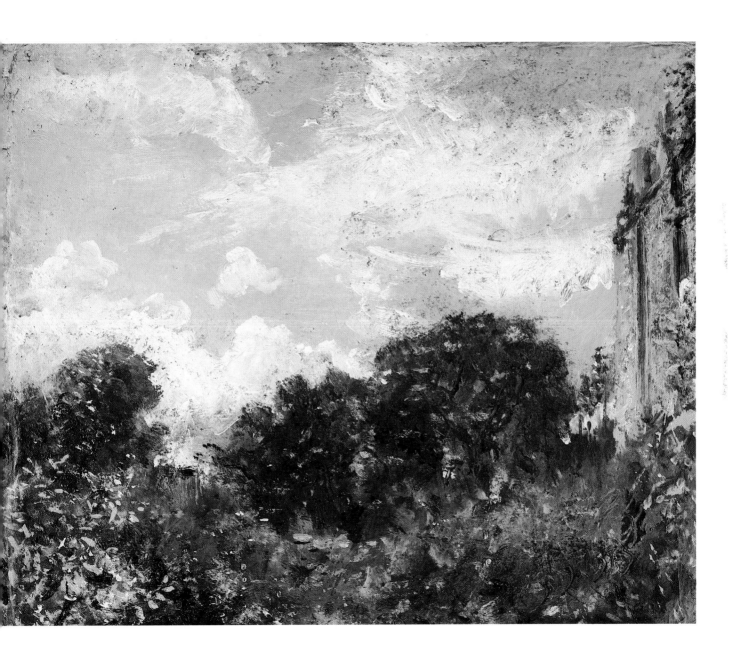

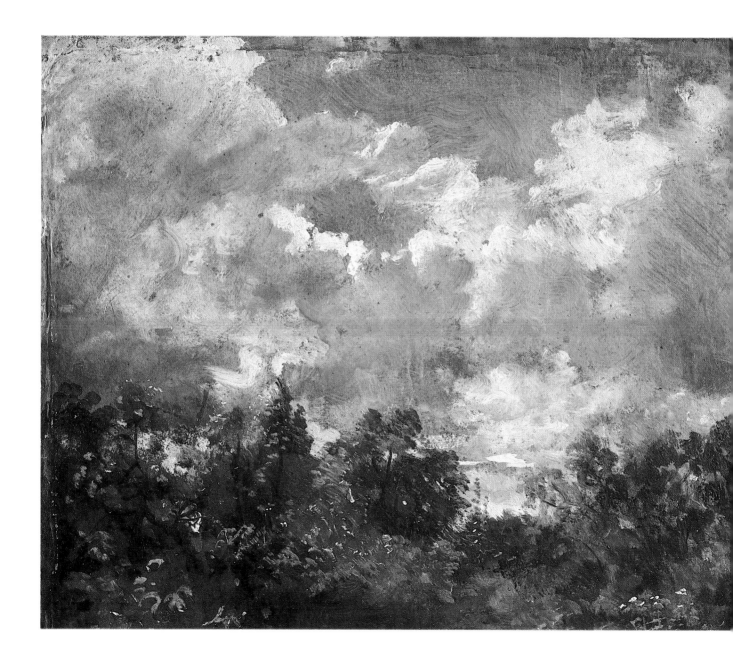

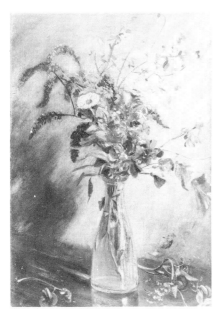

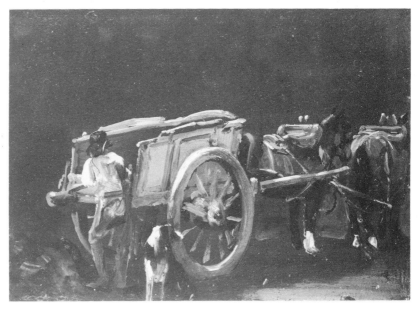

19. STUDY OF FLOWERS IN A
GLASS VASE, c. 1814

20. STUDY OF A CART AND HORSES, WITH A
CARTER AND DOG, 1814

1809–16: The Attainment of Mastery

From 1809 Constable concentrated on oil sketches made from nature and the period 1809–16, which coincides with his protracted engagement to Maria Bicknell, marks a revolution in his style and the emergence of his true greatness. The extent of the revolution may be appreciated in comparing the *Village fair at East Bergholt* of July 1811 [13] with the *Dedham Vale* of 1802 [5]. The symmetrical composition, the brownish-green tones and the unified light of the latter have been replaced by a more direct and immediate depiction of natural phenomena. A dark sky is pierced by brilliant shafts of sunlight, and dazzling specks of white highlight the individual figures in the crowd at the fair in a manner that prefigures Impressionist painting.

Most spectacular among the oil sketches of this period is the *Flatford Mill from a lock on the Stour* of about 1811 [II]. Strong colours have been applied in rapid, broad,

almost violent brush strokes over a unifying reddish-brown ground. This is far from the tranquillity with which Constable is sometimes associated. The dramatic impact of the composition is enhanced by the bold diagonals leading the spectator inwards into the picture, in contrast to the gently receding horizontal planes of his earlier works. Other sketches of this period, for example the *Dedham Mill* [IV], are different in technique, with broader layers of colour, but the immediacy of the confrontation with nature is apparent in them all. "I live almost wholly in the fields, and see nobody but the harvest men", he wrote in 1815.

Constable was not alone in painting naturalistic oil sketches at this time for there were others, including Turner, producing them. But for Constable the oil sketch was an independent product of his art, not merely a means

27

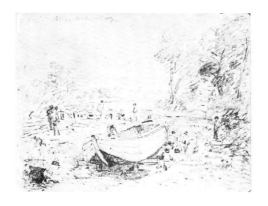

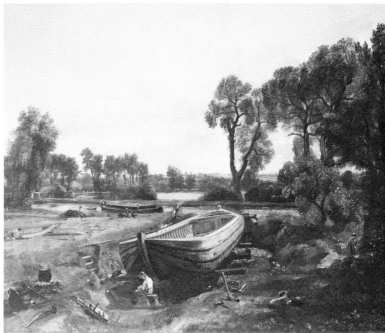

21. STUDY FOR THE PAINTING
BOAT-BUILDING NEAR
FLATFORD MILL, 1814

22. BOAT-BUILDING NEAR FLATFORD
MILL, 1815

to an end, and his work in this medium was more sustained than that of any other artist of the period. Equally, in his aim to become a "natural painter", Constable was not an isolated phenomenon in England. A whole generation of painters was pioneering the art of *plein air* painting; appropriate treatises were being written, and inventions, such as Cornelius Varley's "graphic telescope", perfected to facilitate this practice. This development was surveyed in an exhibition entitled *A decade of English naturalism 1810–20* (Norwich Museum and Victoria and Albert Museum, 1969–70), which assembled the work of Constable and Turner, John and Cornelius Varley, Mulready and Linnell, Cox and De Wint, and several others, to provide a fuller picture than the discussion of any single artist will allow. Nevertheless, Constable remained comfortably in the forefront, for he persisted singlemindedly in pursuit of his aim, whereas Turner became increasingly absorbed in

the drama of cosmic events rather than in the minutiae of rivers and fields.

Naturalism is a term much used in art and yet notoriously difficult to define. It is a truism that nature is infinite and it remains impossible, even if it were desirable, to capture it on a canvas. A field may contain six million blades of grass or a tree two thousand leaves and not the most fanatical naturalist would contemplate reproducing them all. The transition from field and tree onto canvas is bound to be governed by conventional signs which are more or less close to the appearance of the original. For Constable it may be said that his conventional signs, in particular his brush strokes of contrasting colours and his light tonality, based on a close study of actual appearances and transient weather effects, are much closer to the original fields and trees than those of his 18th century predecessors. Certainly this was recognised by his contem-

28

23. VIEW AT EAST BERGHOLT OVER THE
KITCHEN GARDEN OF GOLDING CONSTABLE'S
HOUSE, c. 1812–16

24. ELM TREES IN THE OLD HALL PARK, EAST
BERGHOLT, 1817

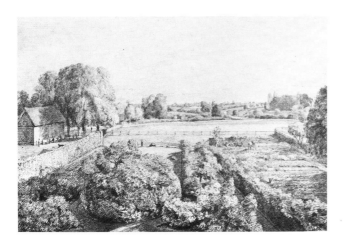

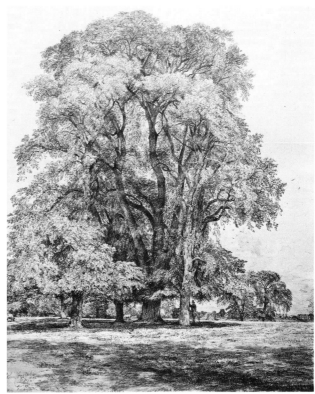

poraries; as Fuseli put it: "I like the landscapes of Constable . . . but he makes me call for my greatcoat and umbrella".

Apart from working on oil sketches, Constable made intensive studies in pencil at this period, which survive in his sketch books of 1813 and 1814 [21]. These tiny drawings were to provide the foundations of many of his paintings in future years. The end of this period is marked by his marriage to Maria Bicknell. She was the granddaughter of Dr Rhudde, Vicar of East Bergholt, who had long considered the impecunious son of the local miller an unthinkably disadvantageous match. Ultimately, the death of his father and the loyal support of his brother Adam who managed the family business, left Constable financially independent and the bride's family was won over. The marriage took place in October 1816 and the honeymoon at Osmington on the Dorsetshire coast is recorded in a series of water-colours and paintings [*cover*] of coastal scenes under grey stormy skies. Subsequently, in the summer of 1818, the couple spent some time at the house of Maria's father on Putney Heath, London, which is also the subject of a light and delicate water-colour [25].

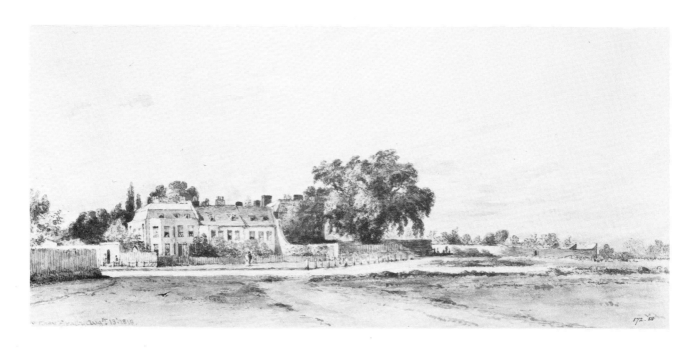

25. HOUSES AT PUTNEY
HEATH, 1818

26. WATERLOO BRIDGE
FROM WHITEHALL STAIRS,
c. 1819

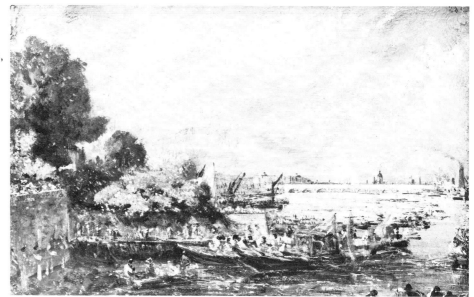

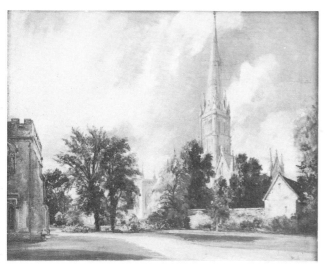

27. SALISBURY CATHEDRAL AND CLOSE, 1820

1819–24: Six-foot canvases, Hampstead and Cloud studies; Salisbury and Brighton

The year 1819 provides another landmark in Constable's career. He exhibited the first of his large canal scenes, the "six foot canvases", at the Royal Academy. This was the *White Horse* (Frick Gallery, New York) and it was followed in the succeeding years by *Stratford Mill* (1820; Macdonald-Buchanan collection) and the *Haywain* (1821; National Gallery), and for the next decade these large academy pieces were to be at the centre of his endeavour. Outstanding in the Museum's collection are the full size studies for two of the most famous of the six foot canvases—*The Haywain* and *The Leaping Horse* (1825; Royal Academy). It was Constable's practice to paint these large sketches—which were usually based on earlier studies done in the countryside—to help him finalize the composition in

28. FULL-SCALE STUDY
FOR 'THE HAY WAIN',
c. 1821

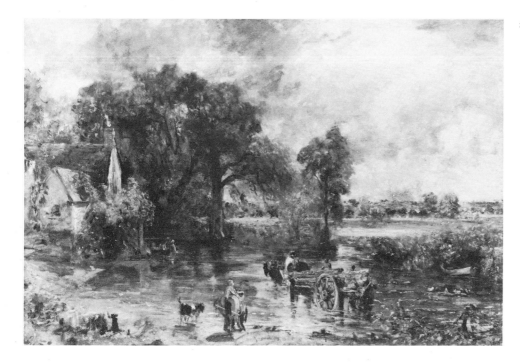

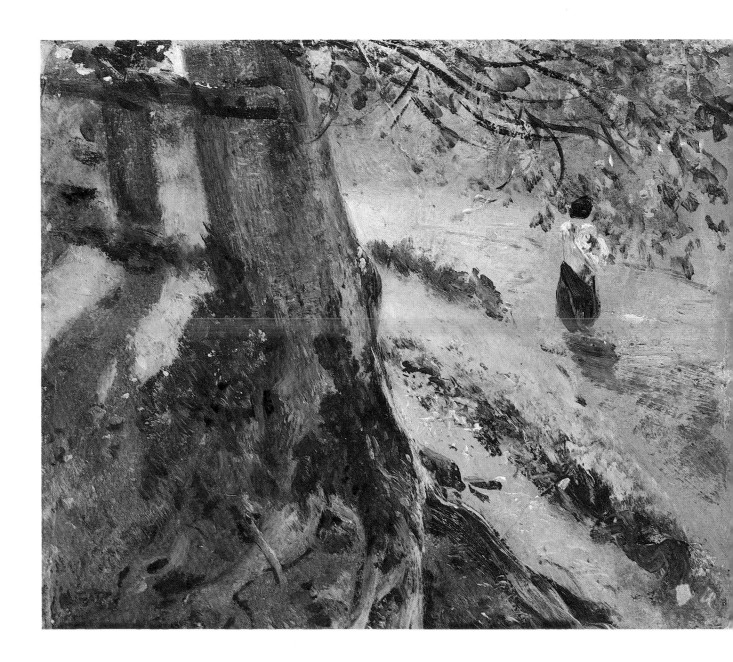

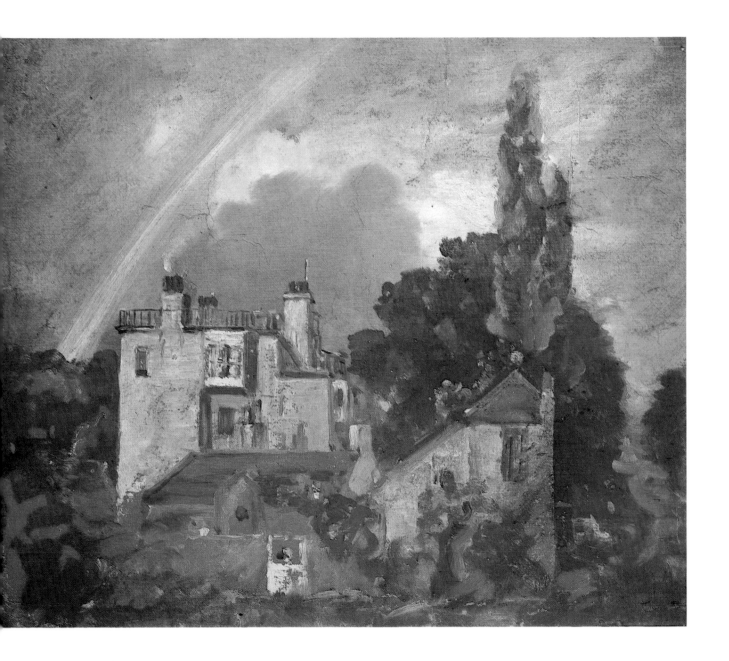

29. A WATER-MILL AT NEWBURY, BERKS, 1821 31. A SANDBANK AT HAMPSTEAD HEATH, 1821

30. THE OLD BRIDGE AT ABINGDON, BERKS, 1821 32. BRANCH HILL POND, HAMPSTEAD (?)

general terms before embarking on the detail of execution demanded by the Academy exhibition pieces. Yet although their purpose was identical, the relationship of sketch and exhibition picture is not the same in both cases. In *The Haywain* sketch [28] the details are only roughly indicated, the background merely blocked in and the predominant tone provided by the light brown canvas on which it is painted. By contrast, the full scale sketch of *The Leaping Horse* [38] is much more finished in both colour and detail.

In 1819 Constable was elected Associate of the Royal Academy, a very belated and half-hearted recognition when it is remembered that of his contemporaries, Turner had been a full member since 1802 and Mulready, ten years his junior, since 1816. Indeed, it could be said that full formal recognition came to Constable first of all in France for in 1824 he won a gold medal at the Paris Salon for the *Haywain*, five years before he was elected R. A. in London.

Constable had spent his winters in London since 1800,

returning to East Bergholt for the summer months, but in 1819 he bought a house in Hampstead and from then on scenes of that district appear frequently in his work [VI, VII, X; 31–2, 34–6, 41, 48]. Yet his Academy pictures continued to be based on sketches he had made in earlier years in Suffolk. The *Dedham Mill* of 1820 [IV] was based on the sketch of 1810–15 [V]. Identical in composition, the broad treatment and rough surface of the sketch has been brought into sharper focus by firmer contours and greater clarity of light, as was expected of a 'finished' picture.

Meanwhile he was extending the geographical areas of his activities. His visits to Salisbury, where his friend and patron Dr Fisher was bishop and where he had sketched as early as 1811 [15], became more frequent [27, 33, 42–3] and the view of the cathedral which he exhibited at the Royal Academy in 1823 remains one of his most famous paintings. A visit to Berkshire in June 1821 is recorded in

33. OLD HOUSES ON HARNHAM BRIDGE, SALISBURY, 1821 (retouched 1831)

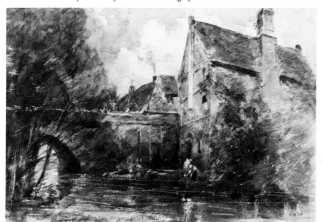

34. TREES, SKY AND A RED HOUSE, c. 1821-3

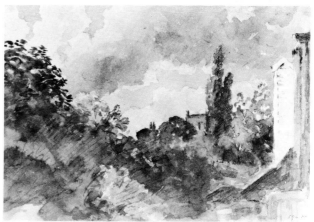

a sketchbook which shows his mastery of a variety of drawing techniques. The *Water-Mill at Newbury* [29] has a loose, rapid, almost wild aspect, in pencil lines and blotches of grey wash, which contrasts with the tightly constricted, parallel striations of the pencil drawing of *Abingdon Bridge* [30].

More famous are the cloud studies which Constable began to draw and paint on the flat stretches and low horizons of Hampstead Heath in 1821 [VII–VIII, 34–5]. Clouds had become fashionable not only in Romantic painting and literature, but also as a source of scientific study. In a stimulating book on Constable's clouds, Kurt

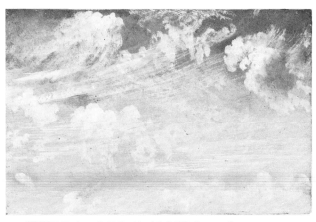

35. STUDY OF CIRRUS CLOUDS, c. 1822

36. CENOTAPH TO SIR JOSHUA REYNOLDS AMONGST LIME TREES IN THE GROUNDS OF COLEORTON HALL, LEICESTERSHIRE, 1823

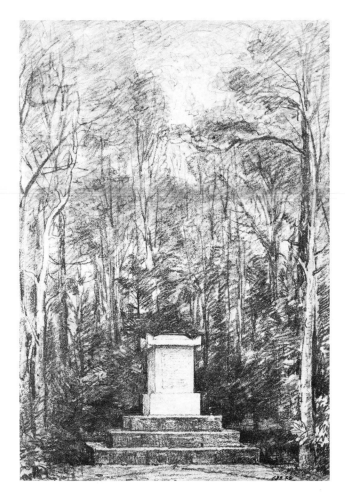

Badt attempted to demonstrate the artist's debt to the meteorologist Luke Howard, whose standard work on the classification of clouds, *The Climate of London*, was published in 1818–20 and immediately acclaimed by Goethe. This hypothesis has not gone unchallenged, but recently John Thornes, a specialist in meteorology, has demonstrated conclusively that Constable was indeed aware of Luke Howard's system of cloud classification. For Constable himself owned and annotated a copy of Thomas Forster's *Researches about Atmospheric Phenomena* (2nd edition, 1815)—which contained Howard's classification—adding his own comments in the margins. It is true that

37. HOVE BEACH, WITH FISHING BOATS, c. 1824

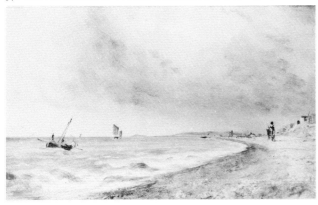

38. FULL SCALE STUDY FOR 'THE LEAPING HORSE' c. 1825

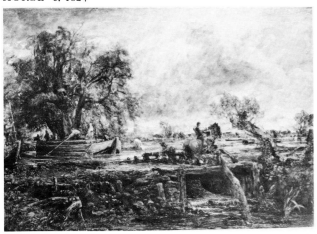

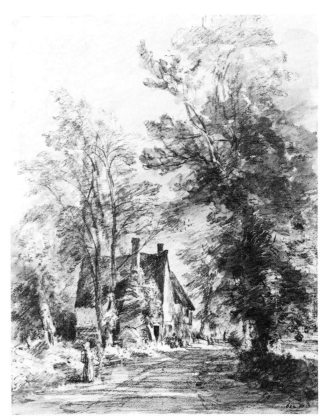

39. WATER LANE, STRATFORD ST. MARY, SUFFOLK, 1827

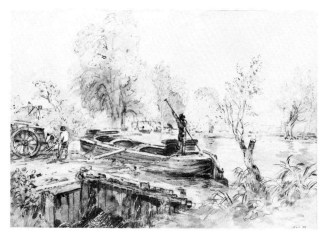

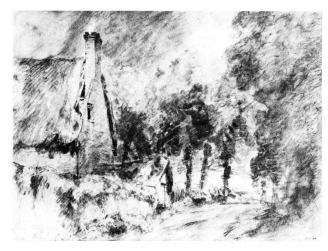

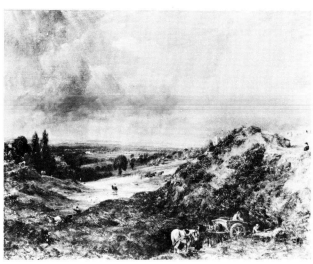

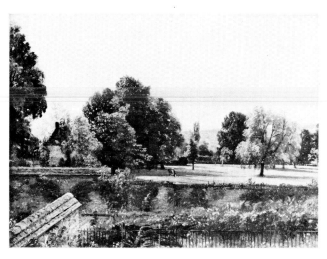

40. MAN LOADING BARGES ON THE STOUR, 1827

41. HAMPSTEAD HEATH: BRANCH HILL POND, 1828

42. A COTTAGE AND TREES NEAR SALISBURY, 1829

43. A VIEW AT SALISBURY FROM ARCHDEACON FISHER'S HOUSE, 1829 (?)

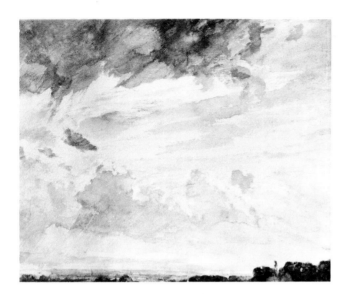

Constable was not alone in making cloud studies in about
1820—indeed, he was preceded by Turner—but there
can be no doubt that he was conversant with current
meteorological theories.

Constable himself had been much concerned with
clouds for many years, as the sketches of 1810–16 demon-
strate, and it is his cloud studies which best illuminate the
apparent contradiction between his naturalism and his
position as a leading member of the romantic movement.

"Painting should be understood . . . as a pursuit, legiti-
mate, scientific, and mechanical". "Painting is with me but
another word for feeling". These two statements of Con-
stable's have often been contrasted. His cloud studies alone
can serve to show that they are not contradictory. On the
one hand these are accurate representations of different
types of clouds. *Study of cirrus clouds* [35] is inscribed
cirrus, probably by the artist, and it is usual for these
sketches to be supplied with precise details of the time of
day and weather conditions. Clearly it was important for
Constable to portray his clouds in as naturalistic a manner

as possible. Indeed, such was his insistence on accuracy
that the other weather elements were always correctly
interpreted to fit with the particular cloud formation por-
trayed. And yet his sky studies, often showing the relation-
ship with trees or roof tops [VII, VIII, 34] are highly
expressive works. For Constable recognized the importance
of the sky as the dominant factor in providing the mood of
a picture: "It will be difficult to name a class of landscape
in which the sky is not the 'key note', the 'standard of Scale'
and the chief 'Organ of Sentiment'."

Throughout his career, Constable's clouds were most
frequently stormy or rain-filled and the mood they impart
is one of mellowness, as in the lines, well known to him,
from James Thomson's *Winter*: "Thick clouds ascend, in
whose capacious womb/A vapoury deluge lies . . .".

This discussion of his clouds should not obscure the
fact that Constable applied the same single-minded study
to his portrayal of other aspects of nature—above all trees
[24, IX, 50]. These are not just trees, but individual por-
traits which he produced at all periods of his life. The oil
Study of tree trunks of about 1821 [IX] is one of his most
personal paintings, and, for its naturalistic colouring and
oblique viewpoint, one of the most precociously modern of
all his works.

In 1824 the Constable family visited Brighton for the
sake of his wife's health: the sea air had been prescribed as
a treatment for consumption. Constable hated the resort,
but his oil sketches of the sea coast, painted on a pink-grey
ground brighter than his usual priming, have a freshness
and luminosity that look ahead to the paintings of Boudin
[XI, 37].

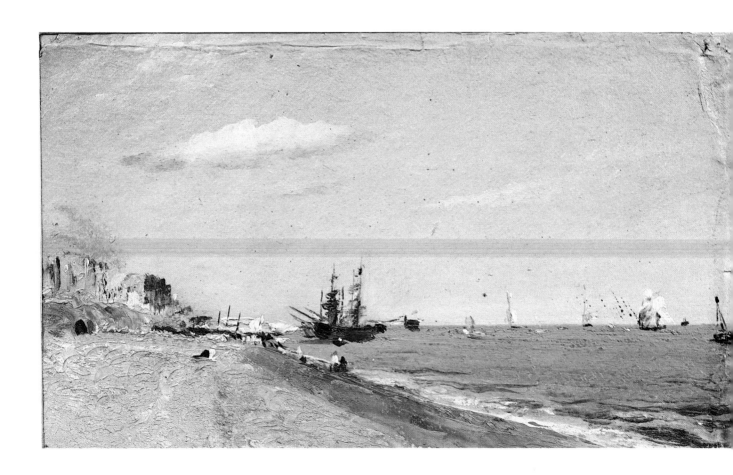

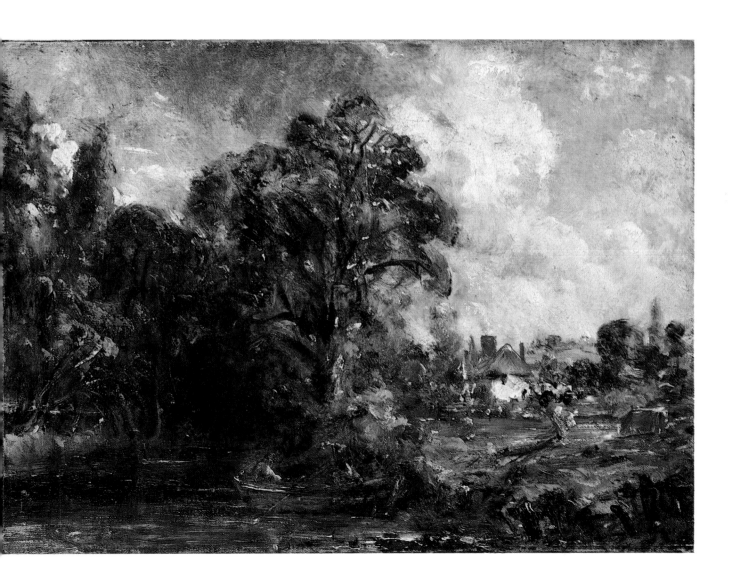

1827–37 The last decade

Maria Constable died in November 1828 and from this date his work took a more violently expressionist direction. Already the *Branch Hill Pond, Hampstead* exhibited in that year [41] is much more sketchy in appearance than the earlier Academy pictures. Indeed, the contrast between the sketch [VI] and the 'finished' picture [41], which had been so marked in earlier years (compare *Dedham Mill*, IV and V), has become much less pronounced. This composition became widely known when it was engraved in mezzotint by David Lucas in 1831.

In his later years Constable produced fewer *plein air* oil sketches, but the production of drawings from nature continued unabated. The charming wash drawing *Men loading barges on the Stour* [40] made on a holiday in his

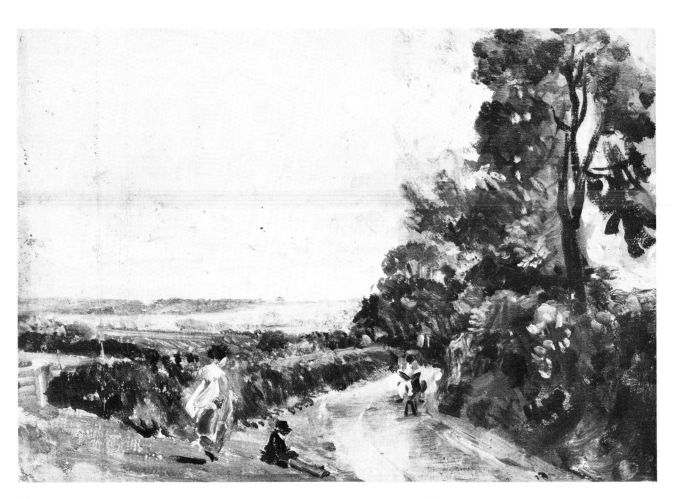

native haunts in October 1827, shows Flatford Mill on the left. The canal subject and the study of labourers at work are both equally typical of Constable's art throughout his career. Dedham Church has been inserted in a fictional position in the distance: one of the few occasions when he tampered with the accurate representation of major landmarks.

From 1830 Constable returned to the consistent use of water-colour, both with and without the addition of pen or pencil outlines. These water-colours are often streaked with white highlights, as are his later oil paintings; the study of *Stoke Poges Church*, dated July 1833, provides an example of this technique [47]. It is one of a series of designs for illustrations to Gray's *Elegy written in a country churchyard*, the only literary illustration he ever carried out.

His late oil paintings are characterized by the use of the

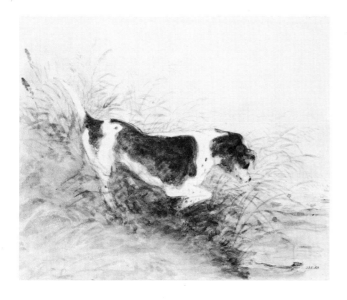

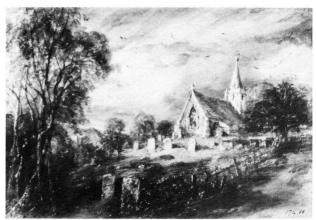

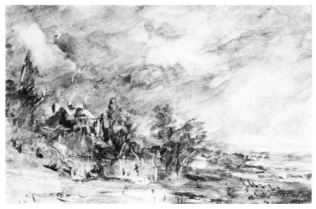

45. A COUNTRY ROAD WITH TREES AND FIGURES, c. 1830

46. A DOG WATCHING A RAT IN THE WATER AT DEDHAM, 1831

47. STOKE POGES CHURCH, BUCKINGHAMSHIRE, 1833

48. HAMPSTEAD HEATH FROM NEAR WELL WALK, 1834

palette knife and the application of thick impasto, particularly for the highlights, which are streaked over the surface. The two late oil sketches reproduced [XII, 52] are examples of this technique. They do not represent identifiable scenes and were probably painted in the studio, but they retain much of the freshness of the earlier sketches. Yet even at this period of violently applied impasto, Constable could produce the water-colour of the *Suffolk Child* [51], the epitome of tranquil charm. This drawing was used for the country woman seated in the boat in the *Valley Farm*,

49. PETWORTH HOUSE FROM THE PARK, 1834

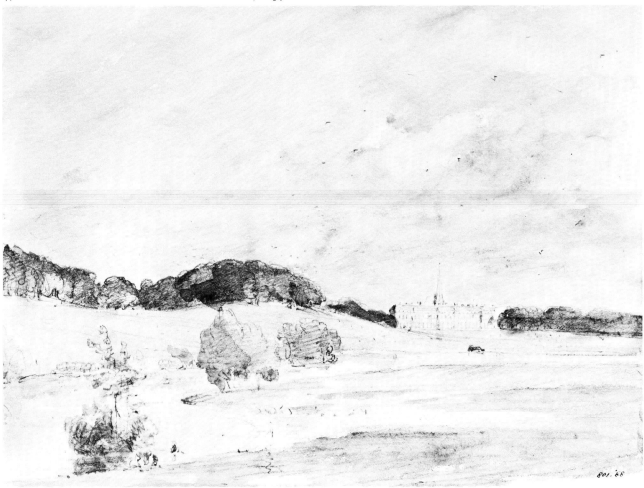

exhibited in 1835 (Tate Gallery). But the *Suffolk Child* is untypical of his later drawings which became ever more broad in technique and visionary in conception. The powerful sepia sketch in particular [53], though based on an earlier composition, shows a conceptual view of landscape rather unlike the detailed naturalism of the great bulk of his work.

It remains to add what is perhaps obvious, that Constable, like all great landscape painters, has affected our way of seeing the English countryside. Just as Mont S.

50. AN ASH TREE, 1835

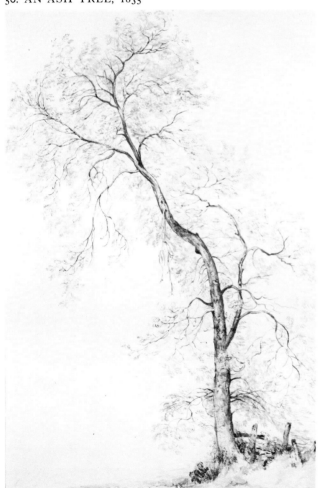

51. A SUFFOLK CHILD: sketch for *The Valley Farm*

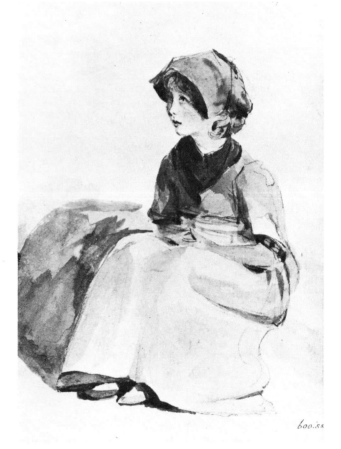

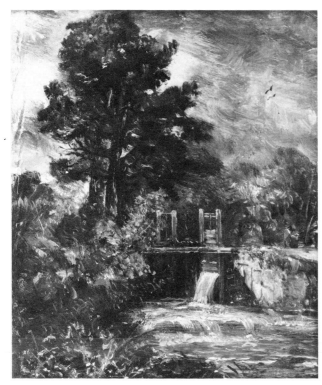

52. A SLUICE, PERHAPS ON THE STOUR: TREES
IN THE BACKGROUND, c. 1830–6

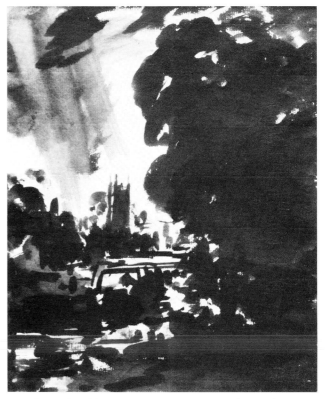

53. VIEW ON THE STOUR, DEDHAM CHURCH
IN THE DISTANCE, c. 1832–6

Victoire is unthinkable without Cézanne, so we think of East Anglia, Hampstead Heath, Salisbury Cathedral and, most of all perhaps, the clouds of England in terms of Constable. With the publication of Lucas's mezzotints of Constable's *English Landscape Scenery* his compositions became widely known and he was accorded some of the deserved acclaim for which he had struggled so long. The painter himself described the following incident in a letter to Lucas of 1832:

"In a coach yesterday, coming from Suffolk, were two gentlemen and myself, all strangers to each other. In passing the vale of Dedham, one of them remarked, on me saying it was beautiful, 'Yes, sir, this is Constable's country'."

Constable on his art

"The landscape painter must walk in the fields with an humble mind. No arrogant man was ever permitted to see nature in all her beauty" (p. 327).

"I imagine myself driving a Nail; I have driven it some way, and by persevering I may drive it home. . . ." (p. 131).

"The sound of water escaping from mill-dams, etc., willows, old rotten planks, slimy posts, and brickwork, I love such things" (p. 85).

"Shakespeare could make everything poetical; he tells us of poor Tom's haunts among 'sheep cotes and mills'. As long as I do paint, I shall never cease to paint such places" (p. 86).

"Painting is with me but another word for feeling, and I associate 'my careless boyhood' with all that lies on the banks of the Stour; those scenes made me a painter, and I am grateful" (p. 86).

"Does not the Cathedral look beautiful among the golden foliage? its solitary grey must sparkle in it" (p. 86).

"Everything seems full of blossom of some kind and at every step I take, and on whatever object I turn my eyes, that sublime expression of the Scriptures, 'I am the resurrection and the life', seems as if uttered near me" (p. 73).*

"The world is wide; no two days are alike, nor even two hours; neither were there ever two leaves of a tree alike since the creation of the world; and the genuine productions of art, like those of nature, are all distinct from each other" (p. 273).

"Light—dews—breezes—bloom—and freshness; not one of which has yet been perfected on the canvas of any painter in the world" (p. 218).

* Constable was here recollecting a remark made to him by Wordsworth.

"I never did admire the autumnal tints, even in nature. so little of a painter am I in the eye of common-place-connoisseurship. I love the exhilarating freshness of spring" (p. 222).

"That landscape painter who does not make his skies a very material part of his composition, neglects to avail himself of one of his greatest aids" (p. 85).

"It will be difficult to name a class of landscape in which the sky is not the key note, the standard of scale, and the chief organ of sentiment" (p. 85).

"My limited and abstracted art is to be found under every hedge and in every lane, and therefore nobody thinks it worth picking up" (p. 203).

The page numbers given above refer to Jonathan Mayne's edition of C. R. Leslie's *Memoirs of the Life of John Constable*.

Select bibliography

Constable's own writings
Constable's views have been filtered to posterity through the writings of his friend, the painter C. R. Leslie, whose *Memoirs of the Life of John Constable* has run to several editions and remains a basic work (most recently edited by J. H. Mayne, Phaidon, 1951). *John Constable's Correspondence* edited by R. B. Beckett for the Suffolk Records Society (6 vols., 1962–68) is now available in full and *John Constable's Discourses* (1970) have also been published by the same editor. The series was concluded by L. Parris, C. Shields, I. Fleming-Williams, *John Constable further documents and correspondence*, 1975. Constable's writings are fully discussed and related to his paintings in an outstanding dissertation by Louis Hawes, *John Constable's writings on art*, Princeton, 1963 (typescript available in the V & A Library).

General works
Of the considerable number of general books on Constable, those by Graham Reynolds, *John Constable the Natural*

Painter, 1965, and Basil Taylor, *Constable: Paintings, Drawings and Watercolours*, 1973, are the most instructive. A. Smart and A. Brooks, *Constable and his country*, 1976, analyzes admirably the artist's twin roots in his native Suffolk and in the pictorial traditions of England and the Netherlands. E. H. Gombrich's classic work *Art and Illusion: a study in the psychology of pictorial representation* discusses the meaning of Constable's naturalism. For an understanding of Constable's popularity in the 19th century it is necessary to consult Lucas's mezzotints: Hon. Andrew Shirley, *The Published mezzotints by David Lucas after Constable*, Oxford, 1930, and a more recent edition edited by Andrew Wilton, 1980.

Sketches

These are discussed and reproduced in: Jonathan Mayne, *Constable sketches*, Faber Gallery, 1953; John Baskett, *Constable oil sketches*, 1966, and Ian Fleming-Williams, *Constable: Landscape, Watercolours and Drawings*, 1976. The Museum's sketchbooks are reproduced in facsimile with an introduction by Graham Reynolds: *John Constable's sketchbooks of 1813 and 1814*, H.M.S.O., 1973.

Specialist studies

Constable's link with Gainsborough, particularly in his drawings, is discussed by John Hayes, "The drawings of George Frost", *Master Drawings*, IV, 1966, p.163 ff. His debt to Rubens is analyzed in a German dissertation: J. G. Böhler, *Constable und Rubens*, Munich, 1955 (available in the V & A Library). The "attainment of mastery" is dealt with in an important article by Michael Kitson, "John Constable 1810–1816: a chronological study", *Journal of the Warburg and Courtauld Institutes*, XX, 1957, pp. 338–357. Detailed studies of two of Constable's major themes are: Graham Reynolds, *John Constable: Salisbury Cathedral from the Bishop's Grounds*, National Gallery of Canada, Ottawa, 1977, and Louis Hawes, *Constable's Stonehenge*, V & A Museum, 1975. On the cloud studies, Kurt Badt, *Constable's Clouds*, 1950, first proposed a direct link with Luke Howard. This was queried by Louis Hawes "Constable's sky sketches", *Journal of the Warburg and Courtauld Institutes*, XXXII, 1969, p. 344 ff, but recently John Thornes, "Constable Clouds", *Burlington Magazine*, CXXI, 1979, pp. 697–704 (with further bibliography), has shown conclusively that Constable was fully conversant with current meteorological studies. Charles Rhyne, "Fresh light on Constable", *Apollo*,

LXXXVII, 1968, p. 227 ff, is a perceptive book review; and Graham Reynolds, "Constable at work", *Apollo*, CXVI, 1972, p. 12 ff, charts the artist's working methods from earliest sketch to finished painting. There are two recent pamphlets on Constable's topography: Celia Jennings, *John Constable in Constable Country*, East Bergholt, 1976, and Olive Cook, *Constable's Hampstead*, Carlile House Press, 1976. The problem of confusion with works by Constable's son Lionel is brought out by Leslie Parris & Ian Fleming-Williams, "Which Constable?", *Burlington Magazine*, CXX, 1978, p. 566 ff.

Catalogues

Graham Reynolds, *V & A Museum: Catalogue of the Constable Collection*, 2nd edition 1973, is a basic work of reference. Other catalogues of major collections include: Martin Davies, National Gallery, *The British School*, 2nd edition 1959; *John Constable, a selection of paintings from the collection of Mr and Mrs Paul Mellon*, National Gallery of Art, Washington, 1969, and Reg Gadney, *John Constable R.A., A Catalogue of Drawings and Watercolours. . . . in the Fitzwilliam Museum, Cambridge*, Arts Council, 1976. Pending the publication of the Tate Gallery's catalogue, C. Shields and L. Parris, *John Constable*, Tate Gallery, 1969, is a useful guide. *Constable: the art of nature*, Tate Gallery, 1971, is a small catalogue of an interesting didactic exhibition; finally L. Parris, I. Fleming-Williams and C. Shields' catalogue of the bicentenary exhibition: *Constable: Paintings, Watercolours and Drawings*, Tate Gallery, 1976, is an indispensable work of reference. R. Hoozee, *L'Opera Completa di Constable*, Milan, 1979, contains a complete catalogue of the paintings.

Printed in England for Her Majesty's Stationery Office by Ebenezer Baylis & Son Ltd., The Trinity Press, Worcester, and London
Dd 696355 C150